CROSS-REFERENCES
SCULPTURE INTO PHOTOGRAPHY

JAMES
CASEBERE

BERNARD
FAUCON

SANDY
SKOGLUND

BRUCE
CHARLESWORTH

RON
O'DONNELL

BOYD
WEBB

Acknowledgments

Walker Art Center
Minneapolis, Minnesota
20 September to 13 December 1987

Museum of Contemporary Art, Chicago
Chicago, Illinois
29 January to 3 April 1988

Cross-References: Sculpture into Photography has been supported by a grant from the National Endowment for the Arts. Additional funding has been provided by The British Council.
Major support for the Walker Art Center exhibition program is provided by The Bush Foundation. Additional support is provided by the Dayton Hudson Foundation for Dayton's and Target Stores, the General Mills Foundation, the Honeywell Foundation, The McKnight Foundation, The Pillsbury Company Foundation and the Minnesota State Arts Board, through an appropriation by the Minnesota State Legislature.

LC 87-051247
ISBN 0-935640-26-6

An exhibition such as this one, for which artists are commissioned to create new works and a large number of variables remain unknown up to the last minute, requires the good faith and generous commitment of many parties. Special thanks are due therefore to the installation crew, working under the direction of Steve Ecklund, and the graphic designers on this project, Jeffrey Cohen and Lorraine Ferguson; to Michael Danoff, director, Museum of Contemporary Art, Chicago, whose institution will host *Cross-References* this winter; and, of course, to Walker Art Center director Martin Friedman, whose support was instrumental in the development of the exhibition. The willingness of the artists to participate was the critical ingredient, and their enthusiasm from the outset has made it a great pleasure for all of us. We would like to extend our heartfelt thanks to the artists for their sustained and dedicated labors on behalf of the exhibition.

Additional thanks are due the editor of this catalogue, Sheila Schwartz, who generously accommodated a tight schedule; Brian Hassett, Sheri Stearns and Michelle Piranio, for their able secretarial and organizational assistance; curatorial intern Nora Heimann, who worked on all aspects of the exhibition; registrar Sharon Howell, who was responsible for the shipping and crating of an extremely varied group of objects from overseas and within the United States; Mike Reed, who assisted with James Casebere's installation; and Glenn Halvorson and Peter Latner, many of whose installation photographs are reproduced in this catalogue. The artists' dealers, among them Michael Klein, Pat Caporosa and Karen de Jong, Anthony d'Offay and Robin Vousden, and Thomas Barry, kindly cooperated with us in providing photographs and tracking down loans. Paulo Colombo was also very helpful in this regard. Finally, the lenders themselves are gratefully acknowledged for their generosity in sharing their works with audiences in Minneapolis and Chicago.

EA, MG, ADW

Lenders to the Exhibition

Arts Council of Great Britain
London, England

Thomas Barry Fine Arts
Minneapolis, Minnesota

The Capital Group, Inc.
Los Angeles, California

Castelli Uptown
New York, New York

Bruce Charlesworth

Anthony d'Offay Gallery
London, England

First Bank System, Inc.
Minneapolis, Minnesota

Michael Klein, Inc.
New York, New York

Ron O'Donnell

Dr. Paul Sternberg, Jr.

A. Robert Towbin

One private collection

cover:
Bruce Charlesworth
Untitled 1987
Cibachrome

Introduction

The idea for this exhibition came from our interest in the direction of much recent photography, in which imagery is manipulated by artists specifically for the camera. These artists have little interest in photography as documentation of visual fact; rather, they prefer to arrange events to create their own realities. While the style of their photographic imagery has been influenced by film, television and literature, their subject matter is drawn ultimately from the creative imagination.

A significant number of artists working today have integrated photography with the other visual arts. *Cross-References* selects from this increasingly diverse group six artists from Europe and America: James Casebere (New York), Bruce Charlesworth (Minneapolis), Bernard Faucon (Paris), Ron O'Donnell (Edinburgh), Sandy Skoglund (New York), and Boyd Webb (London). Their images, although highly individualistic, share decidedly enigmatic, even surrealistic qualities, juxtaposing the real with the artificial and generating dreamlike states of mind.

All of these artists make large-scale constructions, which they usually destroy after their photographs have been made. For this exhibition, we invited them to create new installations that would be shown in the galleries in direct proximity to a group of related photographs. Not only did we consider their sculptural work significant on its own artistic merits, but we wanted viewers to have the opportunity to see how these artists use the camera to transform three-dimensional subject matter into two dimensions.

By fabricating their own subject matter, these artists maintain an unusual degree of control over the resulting photographs. This "source material" ranges from Ron O'Donnell's living room assemblage, chock-a-block with kitschy household fixtures, to Bernard Faucon's minimal glass box filled with hundreds of pounds of crystal sugar. O'Donnell's work, which combines painting, sculpture and collage, has a theatricality that carries over into his photographs. Faucon's elegant sealed case of sugar provides an analogue to the medium of photography, a medium that confines the world within the paper's surface, and his theoretical approach to the project reflects the conceptual roots of his photography.

The hermetic presence of Faucon's work is magnified in James Casebere's room-sized tableau designed for this exhibition. His arrangements of larger-than-life, monochromatic forms simulate monuments, while his melodramatically lit black-and-white prints suggest places that look real but never existed, mythical interiors of iconic proportions. Bruce Charlesworth, on the other hand, has designed a set meant to be explored: steps and open doorways lead the viewer through a vaguely familiar space; a couch placed in front of a perpetually turned-on TV offers further interaction. Yet his subtle manipulation of props and architectural elements in his installations and photographs results in a profound sense of disorientation.

Sandy Skoglund carries directorial photography to its ultimate extreme, retaining strict control over every detail that leads to the production of her photographs. For this new installation she acts as designer, director and producer, personally fabricating dozens of lifelike leaves that cover a moody office interior. Like other artists in the exhibition, she often incorporates people into her sets when using the camera, further activating the situations as they are transposed into photography. Boyd Webb uses the camera to make the artificial appear more real, transforming the simplest materials into hallucinatory imagery. Yet even in his most sumptuous color prints he draws attention to his use of artifice, constantly reminding us that the photograph lies.

While all of these artists work in both photography and sculpture, the range of their visions is considerable, from the private to the public, from the serious to the humorous, from the historical to the contemporary. The camera's unique perspective confers upon their self-made environments an authority that remains intact, even against the competing reality of the neighboring sculptures. The artists' acute understanding of the characteristics unique to each medium, in combination with their powerful, individual viewpoints, yield imagery that extends traditional notions of sculpture and photography.

JAMES CASEBERE

Even in its most palpable form, as large-scale, three-dimensional sculpture, James Casebere's work remains elusive. His environments as well as his photographs are meditations on memory—on the tricks that memory plays on us and the way that photography abets this process. Tackling subjects such as the American West, which automatically evoke the past, Casebere has produced a series of haunting and remote images whose elusiveness suggests the difficulty—and the necessity—of looking back.

Seldom has an artist's career been charted at so early an age as Casebere's. At age five, he was enrolled in an art class that was broadcast on television. On some level, he recognized that more people would see his clay turtle through reproduction than in person. This realization must have influenced his later decision, as an undergraduate, to photograph the three-dimensional models that he made, first using found objects and eventually objects that he constructed himself—all of which were destroyed after being photographed, a working method that he continues to utilize to this day. At his 1984 Sonnabend Gallery show, he did exhibit the models, which were primarily fabricated out of styrofoam and plaster, approximately 30 x 24 x 24 inches. He regarded this exercise as comparable to having a drawing exhibition, though it was not an entirely successful experiment. In the gallery, the models lacked the dramatic lighting and ambiguous scale of the photographs and they were still essentially models and not sculpture.

At the same time, Casebere was pursuing other directions, inserting his photographic images in light boxes and exploring the possibilities of making large-scale versions of his tableaux. The light boxes grew out of his desire to take his art into a larger arena than the gallery—to make public art—which he first attempted by putting his images on posters that he plastered all over downtown New York City. Casebere's light boxes adopt a commercial display mode, so that when placed at sites like the Staten Island Ferry terminal, where they were first shown—or even today in a gallery context—you're not sure whether you're looking at art or advertising. The eerie glow of their fluorescent light only intensifies the air of mystery.

Casebere's first environment, *Back Porch* (1981), a dramatic interior, maintained a more specific relationship to the photographs than do more recent works. Larger-than-life, it was—like the models he had been shooting for many years—made from styrofoam and plaster painted white. Presented in a darkened room, the tableau was highly theatrical and designed to keep the viewer at a distance: its whiteness rendered it insubstantial; it seemed almost to float away.

Recently, however, Casebere has been attempting to make room-size installations that fit more neatly within sculptural traditions. While the images are as mysterious as ever, the forms themselves are sculpted with far more specificity. There is a new concern with surface, and the works are now painted in colors ranging from yellowish white to battleship gray, a monochromatic system that gives them a greater presence. And now the viewer's physical relationship to the work has become critical; its Brobdingnagian scale is intended to make you feel like a child.

Whether Casebere is using oversized three-dimensional elements or, in the photographs, working in miniature, his art suggests childhood and a sense of the past. With few exceptions, his subject matter reveals a keen interest in history, especially America's. Works such as *Cotton Mill* (1983), *Western Street* (1986) and *Western Warplay* (1986) refer generally to episodes in America's past, though none provides us with enough information to determine the exact

where or when of the staged scene. Looking fake and convincing at the same time, like a movie set erected for tomorrow's shoot and a place visited long ago, Casebere's shadowy images imply a past which we reconstruct and revise at will. The story of the American West, in particular, lends itself to this interpretation because it is a tale we have come to know primarily through the movies. Thus the history is as fictionalized as the artist's make-believe sets and photographs, whose black and white presentation refers to early Hollywood Westerns. Instead of appropriating images wholesale from other sources—as a number of artists with similar concerns do—Casebere creates an entirely synthetic version of reality to demonstrate the deceptive ways in which we have learned about ourselves and our culture.

Furthering Casebere's investigation of historical subjects, *Western Sculpture with Two Wagons and Cannon* (1987) features another version of the American frontier. An assemblage of topsy-turvy wagons, a saddle, cannons, guns, and a large assortment of arrows, it also introduces personal artifacts for the first time—a soldier's waistcoat and a boot. There is the clear suggestion of the heroic battle, but as in Casebere's other major environments, there is a comic aspect to all this; it is a tongue-in-cheek war memorial in the tradition of Claes Oldenburg, a memorial whose overblown dimensions suggest it may be a boyhood version of battle.

There is little in Casebere's work that is overt, including its political nature. His antiwar stance was made explicit only in an artist's book he produced entitled *In the Second Half of the Twentieth Century* (1982), which reproduced a statistical table from the *New York Times* detailing, for example, the number of city buses that could be constructed for the amount of money it took to build a certain number of army tanks. But with his mock monuments, he politicizes aesthetics, countering the modern tendency described by the philosopher Walter Benjamin, whom he admires, to aestheticize politics and war.

Casebere's initial impulse to make sculpture was translated into photography because, as he had learned in childhood, photographs could reach more people. Yet the desire to make sculpture, the challenge of creating large-scale, three-dimensional environments, remains within him. His photographs look as though they could easily be transformed into installations and vice versa. The photographs are simulated memories, while his sculptures are simulated monuments. Each medium merges a personal and collective past, even as it confirms the elusiveness of both.

MG

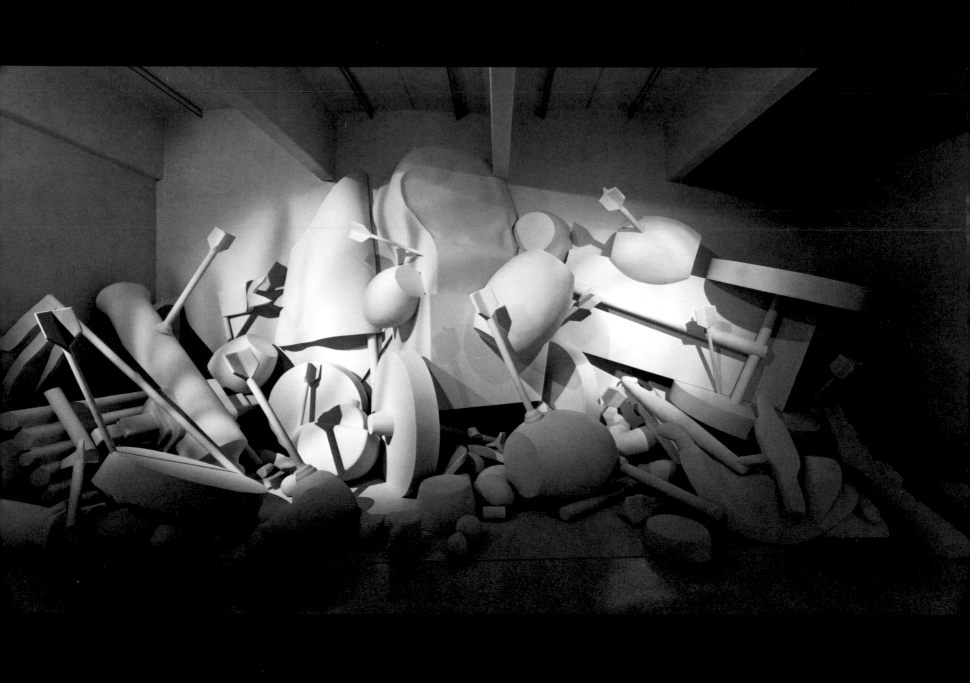

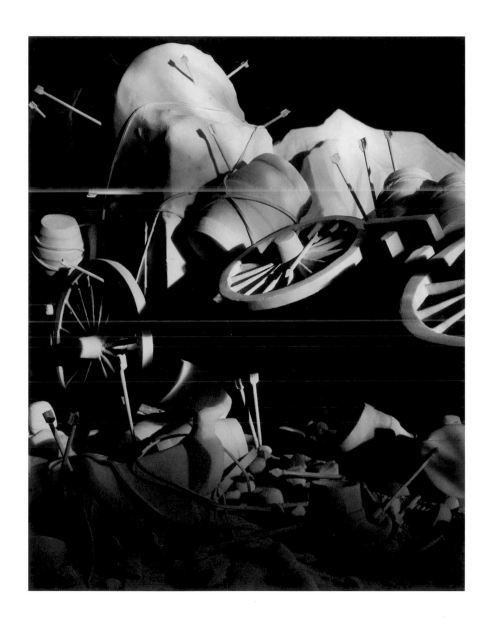

Installation view of
Western Sculpture with
Two Wagons and Cannon 1987
styrofoam, wood, epoxy,
fiberglass, paint

Covered Wagons 1986
Duratran with lightbox

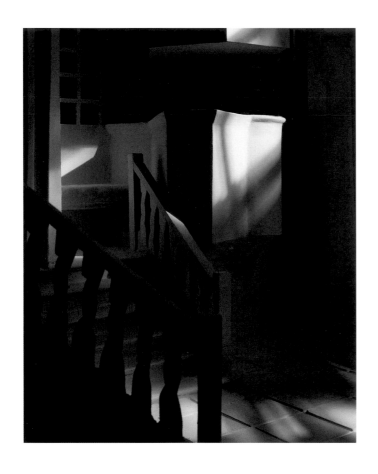

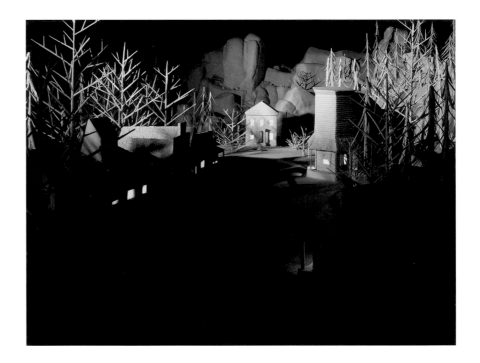

Pulpit 1985
Duratran with lightbox

Western Street 1986
Silverprint

JAMES CASEBERE

1953
Born in Lansing, Michigan
1976
B.F.A., Minneapolis
College of Art and Design
1979
M.F.A., California Institute
of the Arts, Valencia

Lives in New York

Solo Exhibitions
1979
Artists Space, New York
1981
Franklin Furnace, New York
1982
In the Second Half of the Twentieth Century,
CEPA Gallery, Buffalo, catalogue
Sonnabend Gallery, New York
1984
Diane Brown Gallery, New York
Sonnabend Gallery, New York
1985
James Casebere: The Model Picture Show,
Photo-Images 1980-1985, MCAD Gallery,
Minneapolis College of Art and Design
Richard Kuhlenschmidt Gallery, Los Angeles
1987
303 Gallery, New York
Michael Klein, Inc., New York
Kuhlenschmidt/Simon Gallery, Los Angeles

Selected Group Exhibitions
1979
Fabricated To Be Photographed,
San Francisco Museum of Modern Art
(traveling exhibition), catalogue
1980
Group Show, Annina Nosei Gallery,
New York
1981
Eight Contemporary Photographers,
University of South Florida, Tampa
Photo, Metro Pictures, New York
Staged Shots, Delahunty Gallery, Dallas
1982
Mel Bochner and James Casebere,
Sonnabend Gallery, New York
Tableaux: Nine Contemporary Sculptors,
Contemporary Arts Center, Cincinnati,
catalogue
Beyond Photography: The Fabricated Image,
Delahunty Gallery, New York
1983
In Plato's Cave, Marlborough Gallery,
New York, catalogue
Images Fabriquées, Centre Georges
Pompidou, Paris (traveling exhibition),
catalogue
Artists Use Photography,
Marianne Deson Gallery, Chicago

1984
New Sculpture: Icon and Environment,
Independent Curators Inc.
(traveling exhibition), catalogue
Gallery Artists, Sonnabend Gallery,
New York
A Decade of New Art, Artists Space,
New York
1985
1985 Biennial Exhibition, Whitney Museum
of American Art, New York, catalogue
A Life of Signs, Michael Klein Inc., New York
Fictions, Diane Brown Gallery, New York
1986
Photographic Fictions, Whitney Museum of
American Art, Fairfield County, Stamford,
Connecticut
Signs of the Real, White Columns, New York
The Real Big Picture, The Queens Museum,
Flushing, New York
XIX Milano Triennale, Milan
TV Generation, LACE, Los Angeles
Sonsbeek '86, Arnhem, The Netherlands,
catalogue
James Casebere, Clegg + Guttman, Ken Lum,
Galerie Bismarkstrasse, Cologne
*The Fairy Tale: Politics, Desire and Everday
Life*, Artists Space, New York
Foto cliché, Victoria Miro Gallery, London
(traveling exhibition), catalogue
Sculpture on the Wall, Aldrich Museum of
Contemporary Art, Ridgefield, Connecticut
Emerging Artists '86, Cleveland Center for
Contemporary Art
1987
*This Is Not A Photograph: Twenty Years of
Large-Scale Photography, 1966-1986*, John
and Mable Ringling Museum of Art, Sarasota
(traveling exhibition), catalogue
*Arrangements for the Camera:
A View of Contemporary Photography*, The
Baltimore Museum of Art
CalArts: Skeptical Belief(s), Renaissance
Society, University of Chicago, catalogue
*Photography and Art: Interactions Since
1946*, Museum of Art, Fort Lauderdale and
Los Angeles County Museum of Art (traveling
exhibition), catalogue

BRUCE CHARLESWORTH

Bruce Charlesworth's *Private House* (1987) is an environment that functions symbolically. Amid the home furnishings, most of which Charlesworth fabricated, is his recent videotape *Dateline for Danger* (1987), an intentionally overblown cop-gangster-domestic drama about the world of high finance and crime. This video, in which the artist plays one of several characters, runs continuously on a television set in the living room. The installation and video will be incorporated into Charlesworth's new film, *Private Enemy–Public Eye*, currently in production and shot on location in *Private House*. *Private House* will also serve as the set for a new group of photographs that will reflect scenes from the film.

The intricate relationship that has developed among Charlesworth's installations, photographs and videos has grown naturally out of his versatile talents as photographer, sculptor, painter, filmmaker, writer, actor and director. Involved in all of these disciplines since leaving school in the mid-1970s, he began in the 1980s to make videos and design theater sets. Formal and thematic interconnections inherent in these various media find integration in his installations and unify his work as a whole.

An early work such as *Eddie Glove* (1976-1979) contains many of the elements that characterize Charlesworth's mature art. Central to this series of fifty small, sepia-toned photographs is the character of Eddie Glove, an "ordinary" guy to whom things happen. As Eddie, Charlesworth falls through a trap door, gets smashed, is robbed of his gold inlays, and watches the "Late Show," among other things. Captions, written by the artist, enhance this often funny, sometimes frightening, and usually surreal narrative. Charlesworth, who has aptly described his working habits as guerilla-like, shot the series in various locations over the course of four years.

Whether his photographs derive from real locations, theater set designs or sets constructed expressly for the camera, they are painstakingly planned. His recent photographs, large square Cibachromes, exhibit taut visual control and an almost excessive sense of order. Editing out all extraneous detail, he focuses attention on the figure and one or two key props. Each object or set element tends to be painted in a solid color, further emphasizing their simplified, geometric forms. Charlesworth has abstracted these constructions into archetypal furnishings, often built slightly out of scale, that resemble Minimalist sculptures. He has a way of fabricating sets and props to look deceptively two-dimensional, flattened out as if seen through a viewfinder.

When Charlesworth isn't making photographs on location, he uses his house as a studio. Here, he casts himself as an ambiguous protagonist in situations that range from dramatically suspenseful to utterly banal. The power of these photographs derives from the startling juxtapositions between this unlikely actor and the eclectic range of contradictory contexts in which he finds himself. While Charlesworth's studio undergoes striking metamorphoses, from a debris-filled building on the verge of collapse to a fastidious breakfast nook, his central character, still played by Charlesworth himself, changes little. Perennially dressed in a nondescript dark suit, he appears alternately as disoriented, deranged or distraught.

In a particularly melodramatic image, Charlesworth transforms the garage behind his house into a snowbound cabin. Wielding a huge ax, he ominously stalks snowprints in the night. This picture, like many of Charlesworth's photodramas, recalls a familiar type of American fiction, the Hollywood film. Indeed, strongly reminiscent of a scene from *The Shining,* Charlesworth's photograph is too staged to be real, too posed to be a still of spontaneous action. It feels more like a film-studio publicity shot. As in

those promotional photos, which often over-dramatize actions not actually seen in the movie, the scene is presented outside of a narrative context, leaving the outcome unresolved.

On other occasions, Charlesworth's everyman epitomizes normalcy. In one photograph he is seated at a small kitchen table, in front of a bowl of cereal. A small, red wall clock ticks off the minutes as he reads the newspaper. Yet, what we might assume would be a placid breakfast scene is wrought with psychological tension. The camera frames Charlesworth into a claustrophobic box with lighting too intense for a relaxed meal. And, in a world of imagery where deviance is the norm, such hyper-normalcy verges on the maniacal.

In another recent photograph, Charlesworth's awkward character stands alone in a pink-tiled hotel foyer in front of two red doors (designed by the artist when he was commissioned to do sets for a play by Jeffrey Jones entitled *Der Inka von Peru*). These emphatic doors take on a sinister character, overwhelming the bewildered-looking Charlesworth. Carrying a suitcase in each hand, he could not look more ill-at-ease, as if he'd been dropped onto a foreign planet. In another scene, he again finds himself in the wrong room. This time he seems to have wandered into a cartoon hospital ward inhabited by two wary, pink rabbits. Bottle in hand, he has come perilously close to seeing pink elephants.

This dislocated figure seems alternately comical and sinister in the photographs. A related character developed by Charlesworth in his recent play *Utopian Night Life* (1987) takes on an ominous persona. Throughout the play, "Harvey" has the glazed-over look of a somnambulist. Oblivious to potential dangers around him, he seems aware only of the most prosaic details of his existence. This anhedonic being is the ultimate fatalist, programmed to passivity: at the end of the play, he is left staring into the omnipresent television set.

Appropriately, television sets are among Charlesworth's favorite props. In *Private House*, Charlesworth invites the viewer to sit down and watch his videotape, which functions symbolically as a TV show. Like his metaphoric everyman, visitors to Charlesworth's set will be unable to change the dial. They can explore the "house," climb up the stairs, pick up the phone, and look out the windows but, disoriented by the installation's manipulated space and props, they may find watching TV to be the most tangible experience there.

EA

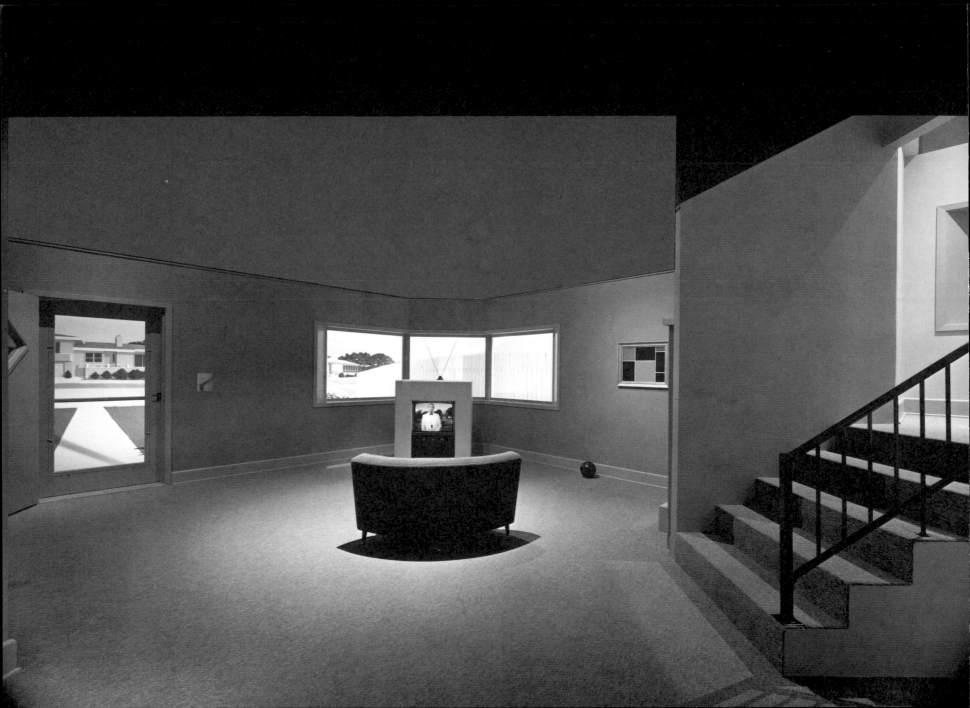

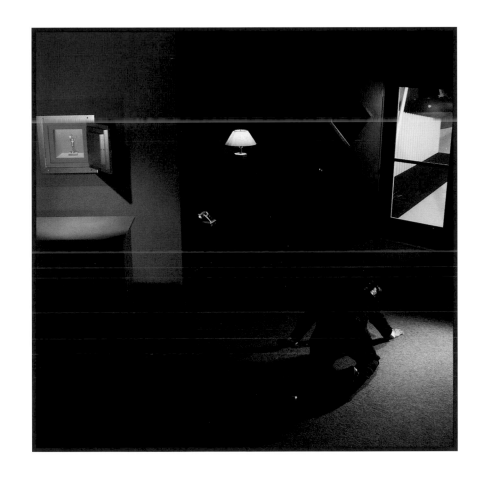

Installation view of
Private House 1987
mixed media with audio and
video elements

Untitled 1987
Cibachrome

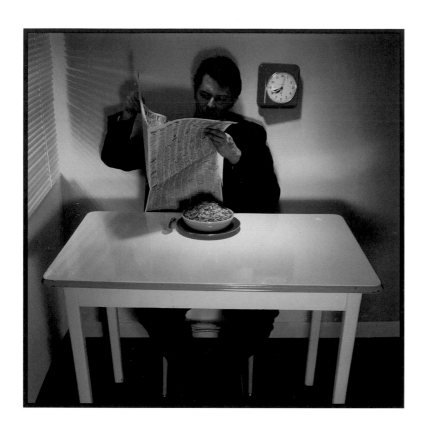

Untitled 1985
Cibachrome

BRUCE CHARLESWORTH

1950
Born in Davenport, Iowa
1972
B.A., University of Northern Iowa,
Cedar Falls
1974
M.A., University of Iowa, Iowa City
1975
M.F.A., University of Iowa, Iowa City

Lives in Minneapolis

Solo Exhibitions
1975
Doris Day in Flames, Clapp Hall,
University of Iowa, Iowa City
1978
Tourist, South Minneapolis
(outdoor slide installation)
1979
Glen Hanson Gallery, Minneapolis
1981
Special Communiqués,
Film in the Cities, St. Paul
1982
Lost Dance Steps, Artists Space, New York
1983
Bruce Charlesworth: New Photographs,
P.S. 1, Long Island City, New York
1984
*Wrong Adventures: An Installation with
Video*, Capp Street Project, San Francisco
Gallery 400, University of Illinois at Chicago,
catalogue

1985
*Bruce Charlesworth: Rooms (Narrative
Environments 1981-84)*, Macalester College,
St. Paul
Trouble: Photographs 1983-85, Tweed
Museum of Art, University of Minnesota,
Duluth
1986
Bruce Charlesworth: New Photographs,
Marianne Deson Gallery, Chicago
Bruce Charlesworth: Works 1982-86,
University of Wisconsin, Stevens Point
1987
Bruce Charlesworth: Abstraction, Thomas
Barry Fine Arts, Minneapolis
Schreiber/Cutler Contemporary Art, New
York

Selected Group Exhibitions
1976
Iowa Artists, Des Moines Art Center
1979
SX-70 Art, Kennedy Gallery, Cambridge,
Massachusetts (traveling exhibition),
catalogue
SX-70, CEPA Gallery, Buffalo, New York
1980
*Bruce Charlesworth, Timothy Lamb:
Photography*, Walker Art Center,
Minneapolis
Likely Stories, Castelli Graphics, New York
Instantanés, Centre Georges Pompidou, Paris
(traveling exhibition), catalogue
1981
Persona, The New Museum of Contemporary
Art, New York, catalogue
Five Emerging Artists, Minneapolis College
of Art and Design, catalogue
1982
Eight Artists: The Anxious Edge, Walker Art
Center, Minneapolis, catalogue
1908-83 Art, 75th Anniversary, Gallery of
Art, University of Northern Iowa, Cedar
Falls, catalogue
Bruce Charlesworth and Marlene Nordstrom,
Tweed Museum of Art, University of
Minnesota, Duluth

1983

1983 Biennial Exhibition, Whitney Museum of American Art, New York, catalogue
The End of the World: Contemporary Visions of the Apocalypse, The New Museum of Contemporary Art, New York, catalogue
Eight McKnight Artists, Minneapolis College of Art and Design (traveling exhibition), catalogue
Language, Drama, Source and Vision, The New Museum of Contemporary Art, New York

1984

The Family of Man: 1956-83, P.S. 1, Long Island City, New York
Sixty Cycles: Bruce Charlesworth and James Byrne, Minnesota Museum of Art, St. Paul
McKnight Photographers, Film in the Cities, St. Paul

1985

Otherland, Ronald Feldman Fine Arts, New York
Weird Beauty, The Palladium, New York
Bruce Charlesworth, Lynn Geesaman, Dan Powell, Thomas Barry Fine Arts, Minneapolis
New Artists/New Works, Marianne Deson Gallery, Chicago
Appearances: Minnesota Photographers, Minneapolis Institute of Art

1986

Before the Camera, Burden Gallery, New York, catalogue
Photographic Fictions, Whitney Museum of American Art, Fairfield County, Stamford, Connecticut
Passages in Time, Los Angeles Center for Photographic Studies, Los Angeles
MAEP Tenth Anniversary Celebration, Minneapolis Institute of Art, catalogue
Intimate/Intimāte, Turman Gallery, Indiana State University, Terra Haute, catalogue
Signs of the Real, White Columns, New York
Made in America: The Great Lake States, Alternative Museum, New York (traveling exhibition), catalogue
Born in Iowa: The Homecoming Exhibition, Gallery of Art, University of Northern Iowa, Cedar Falls (traveling exhibition), catalogue
A Visible Order, Lieberman and Saul Gallery, New York

1987

*Arrangements for the Camera:
A View of Contemporary Photography*, The Baltimore Museum of Art
Surveillance, LACE, Los Angeles, catalogue
Eight McKnight Artists, Minneapolis College of Art and Design (traveling exhibition), catalogue

Films and Videotapes

1974

Plane 50. 16mm animated color film. 2 mins.
The Audition. 16mm black-and-white film. 15 mins.

1975

Jimmy Paradise. 16mm black-and-white film. 10 mins.

1981

Communiqués for Tape. ¾ in. color videotape. 20 mins.
Surveillance. ¾ in. color videotape. 21 mins.

1982

Lost Dance Steps. ¾ in. color videotape. 21 mins.
Projectile. ¾ in. color videotape. 18 mins.

1984

Wrong Adventures. ¾ in. color videotape. 21 mins.

1985

Robert and Roger. ¾ in. color videotape. 45 mins.

1987

Dateline for Danger. ¾ in. color videotape. 24 mins.

Theater Work

1984

Der Inka von Peru, Brass Tacks Theatre, Minneapolis (design)

1985

Driving Around the House, Brass Tacks Theatre, Minneapolis (design)

1986

Tomorrowland, Brass Tacks Theatre, Minneapolis (design)

1987

Utopian Night Life, Brass Tacks Theatre and Walker Art Center, Minneapolis (script, direction, design, acting)

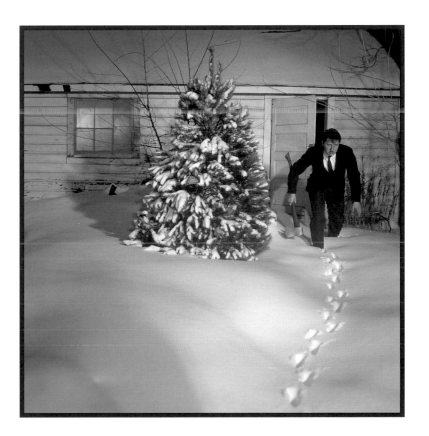

Untitled 1986
Cibachrome

BERNARD FAUCON

When I first discussed the concept for *Cross-References* with Bernard Faucon, he listened shyly, attentively, and quietly assented to create an environment for the exhibition. I was pleased; I imagined a wonderful room full of the porcelain child mannequins he had been collecting for years, theatrically arranged in a poetic tableau, elegantly illuminated and surrounded with nostalgic remnants of his childhood.

To my astonishment, several months later Faucon proposed a work titled *The Wave of Snow* (1987), an enormous glass box filled with hundreds of pounds of crystal sugar. I had, in the meantime, seen his recent photographic series *Rooms of Love* (1984–1986), which he planned to exhibit in the gallery with *The Wave of Snow*. Although these sumptuous photographs of softly lit, pastel-colored spaces were emptied of the haunting mannequins for which he had become known, I had never anticipated that Faucon's concept for an environment would result in a large minimalistic display case enclosing a crystalline snowdrift.

What is the meaning of this sugar, I wondered. In his previous photographic tableaux, Faucon had sometimes used sugar to highlight certain elements or to "draw" in a three-dimensional setting. In his photograph *La Piscine* (1979), a boyish mannequin, with eyes full of wonder, sits in a furrowed field straddling a miniature, biomorphically shaped swimming pool; in the background, a winding driveway of sugar leads to a toy country home with a gable roof and a cupola. In other photographs, such as *Bataille de boules de neige* (1978), snow itself is the primary subject. This image depicts a snowball fight on a hillside among a group of boy mannequins, most of whom are dressed in shorts. Snow is also a significant subject in the *Rooms of Love* series. Using sugar again in *The Snow Storm (The Fourteenth Room)* (1985), Faucon depicts a sensuous snowdrift in a bare room with pastel blue walls. This spartan space reveals a single spiny stem of flowers hanging precariously from the cracked white plaster ceiling and several dried leaves on a snowless patch of terra-cotta tile floor. I surmised that Faucon's frequent and consistent use of sugar must be more than a pictorial device and that snow to him might suggest more than the obvious metaphor of youthful innocence and chastity.

In the introduction to his book *Summer Camp* (1980), Faucon refers to the eating of sweets and equates it with the pleasures of sight and expectation: "Eating candy and cakes is surely above all to devour with one's eyes." Faucon goes on to question the joys and evils of sugar and further wonders at the relationship between sugar and sight. "However, as time goes by I am increasingly worried about something. Why is it said that sugar makes dogs go blind? Could there be a mysterious relationship between sugar and sight? Could the punishment be designed to fit the sin?" Before reading this statement it hadn't occurred to me that Faucon associated sugar with moralistic concerns. While *The Wave of Snow* addresses somewhat different questions from those postulated by the preceding anecdote, I think that it too raises moral issues.

The purity and simplicity of *The Wave of Snow* seem to transcend the mundane world of right and wrong. In the words of Jacques Maritain, the influential philosopher with whom Faucon studied: "Art in itself pertains to a sphere separate from and independent from the sphere of morality. It breaks into human life and human affairs like a moon prince or mermaid into a customs office or congregation." The hermetic purity and isolation of *The Wave of Snow* stands in contrast to the inevitable imperfections and conflicts of daily life. The wave of snow which never melts or shifts in the wind suggests an absolute state of nature which cannot exist except in art; it connotes a state of ideal perfection against which reality can be measured.

Faucon is a purist in his working method as well. In the past, he has always dismantled his installations after the photographs have been made. He has wanted to retain only the perfectly controlled photographic illusion, not the mutable, constructed reality. For him, "a picture is a track, the evidence of something which happened once, somewhere....As soon as I record the setting, it has to be destroyed."

In his installation proposal for *Cross-References,* Faucon explained that he would do quite the opposite—create an environment intended for display, but not photograph it. As he wrote, "when you shoot the real, you are shutting it [in], in an analogic way; but now I want to shut [in] the real scene, in a literal way." *The Wave of Snow* is an object with its own presence and significance. It is frozen, immovable and timeless. It is a container that holds its subject sealed off, separated from the world like a photograph in which "everything must be enclosed in the square of paper."

Faucon's work, I then realized, was not about sculpture becoming a photograph. For him each medium has its own separate existence. Photography, often thought to be a process for transcribing the world, in his work becomes a medium of origination. A photograph is not a copy of something but an original creation from the artist's imagination. Faucon's constructions are a means to an end and therefore not truly cross-references. For this reason he chose not to photograph his installation. *The Wave of Snow* is a sculptural object; a commentary and reflection on the photographs displayed around it.

The crystals of sugar in *The Wave of Snow* constitute a *tabula rasa,* a blank sheet of photographic paper. Yet there is color; light is delicately shattered by the crystals, creating a soft but perceptible chromatic brilliance. It is the writing of light, the beauty of light itself. "Painting is opaque; it makes the support disappear; to the contrary [with photography], color allows one to perceive [the paper]. This is the most evident way to make the materiality of color visible." The snow itself is beautiful, sensual but removed from the context of a winter landscape. The only trace of the artist's presence is the manner in which the snow is distributed within the glass case.

In this exhibition, *The Wave of Snow* is set in a room full of pictures of rooms. It is surrounded by sixteen images from Faucon's series *Rooms of Love.* Rooms of sublime tenderness and delicacy. Mostly empty containers of light. Light passing through windows, emanating from burning coals, transmitted through stained glass. In the empty rooms are traces of presences—faint, primitive wall drawings; fleeting silhouettes across a terra-cotta floor; the corner of a bed with a cloudlike duvet and the visage of a young man in a fogged mirror. Other chambers contain young boys huddled, exposed, bathed in gold and silver light. One room is ambiguously situated. Is it indoors or outdoors? Like *The Wave of Snow,* it appears to be simultaneously within and without. The chamber where this magic is wrought is the camera. Here, three dimensions become two and what no longer exists remains for all to see.

The Wave of Snow is a still life, "nature morte," nature dead. It is the glow of a palpable memory, a transient phenomenon, "an instant of grace" held in perpetual suspension. The words of a kindred spirit, Charles Baudelaire, perhaps best express the essence of this work: "I am beautiful, O mortals! Like a dream of stone and my breast, where each one in turn has bruised himself, is made to inspire in the poet a dream as eternal and silent as matter. I sit in the azure sky like an undeciphered sphinx; I join a heart of snow to the whiteness of swans. . . ."

ADW

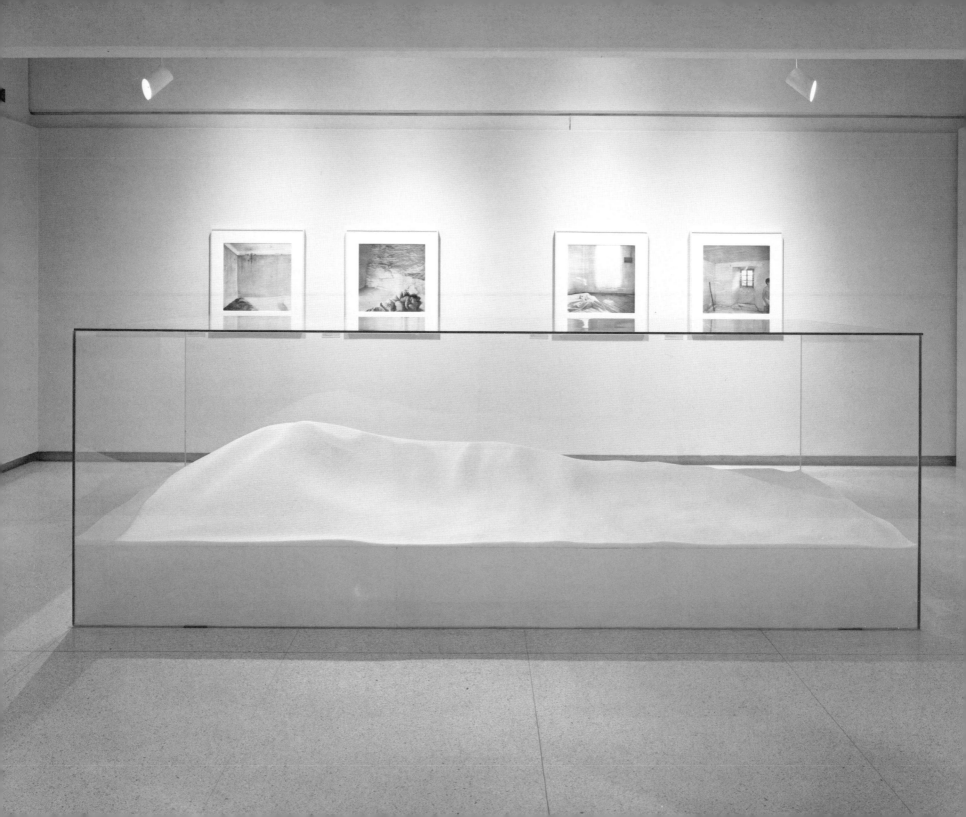

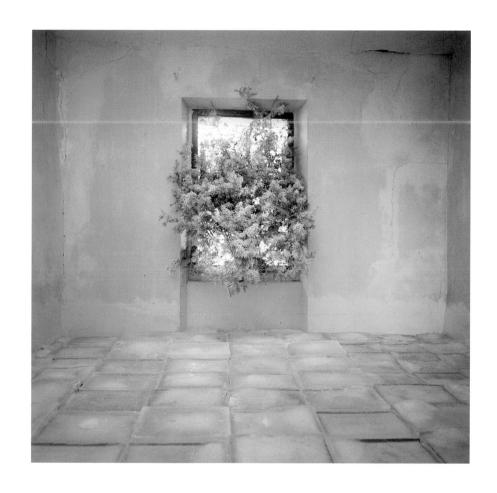

Installation view of
The Wave of Snow 1987
sugar, glass

Room in Winter 1987
Fresson print

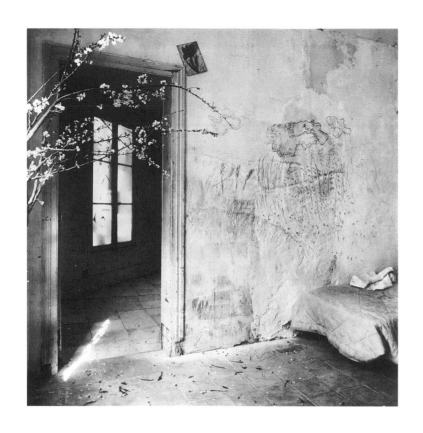

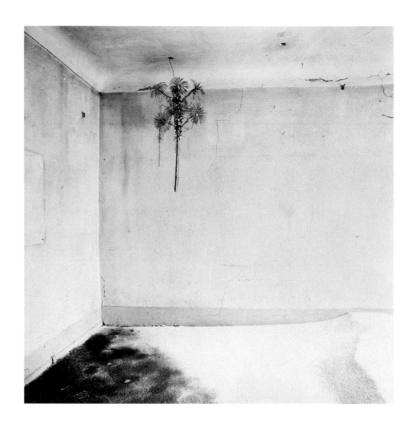

The Fourth Room of Love 1985
Fresson print

The Snow Storm
The Fourteenth Room of Love 1985
Fresson print

BERNARD FAUCON

1950

Born in Apt, France

1974

M.A., Sorbonne, Paris

Lives in Paris

Solo Exhibitions

1977

Galerie Lop-Lop, Paris

Galerie-Librairie la Quotidienne, Aix-en-Provence

1978

Galerie Fotomania, Barcelona

1979

Plaisir, jeux et voyages, Galerie Agathe Gaillard, Paris

Bernard Faucon: Fresson Color Photographs, Castelli Uptown, New York

1980

Galerie t'Venster, Rotterdam

Galerie Canon, Geneva

1981

Galerie Napalm, Saint-Etienne, France

Galerie Junod, Lausanne

Bernard Faucon: Recent Fresson Prints, Castelli Uptown, New York

1982

Galerie Paula Pia, Antwerp

Musée de Toulon, France, catalogue

Zeit Photo Salon, Tokyo

1983

Galerie Fiolet, Amsterdam

Galerie Junod, Lausanne

Castelli Uptown, New York

1984

Galerie Agathe Gaillard, Paris

1985

Axe Actuel, Toulouse, France

Gemeentelijke Van Reekum Galerij, Apeldoorn, The Netherlands

La part du calcul dans la grâce, Galerie Images Nouvelles, Bordeaux

Galerie de Prêt, Angers

Musée Nicephore Niepce, Chalon-sur-Saône, France

Galerie Artem, Quimper, France

Galerie Modulo, Lisbon

Galerie Alexandre de la Salle, Saint-Paul-de-Vence, France

1986

Bernard Faucon: Fresson Prints, Houston Center for Photography

Les chambres d'amour, Galerie Agathe Gaillard, Paris

Bernard Faucon: The Rooms of Love, Castelli Uptown, New York

Galerie Fiolet, Amsterdam

Musée de la Charité, Marseilles, catalogue

Centre d'Art Contemporain, Forcalquier, France

Natural Resources, Houston Center for Photography

Galerie Jade, Colmar, France

1987

Maison de la Culture, Amiens, France

Parco, Tokyo

Stills Gallery, Edinburgh

Institute of Contemporary Arts, London

Galerie Junod, Lausanne

Selected Group Exhibitions

1980

Invented Images, The Santa Barbara Museum of Art (traveling exhibition), catalogue

XII Biennale de Paris, Musée d'Art Moderne de la Ville de Paris, catalogue

Model Photography, CEPA Gallery, Buffalo, New York

1981

The New Color: A Decade of Color Photography, Everson Museum of Art, Syracuse (traveling exhibition), catalogue

Four French Photographers, Friends of Photography Gallery, Sunset Center, Carmel, California

1982

In situ: douze artistes pour les galeries contemporaines, Centre Georges Pompidou, Paris, catalogue

Color as Form: A History of Color Photography, International Museum of Photography, George Eastman House, Rochester, New York (traveling exhibition), catalogue

Staged Photo Events, Rotterdamse Kunststichting, catalogue

Recent Color, San Francisco Museum of Modern Art, catalogue

Photographie France aujourd'hui, Musée d'Art Moderne de la Ville de Paris, catalogue

Beyond Photography: The Fabricated Image, Delahunty Gallery, New York

1983

Peindre et photographier, Espace Niçois d'Art et de Culture, Nice, catalogue

Images Fabriquées, Centre Georges Pompidou, Paris (traveling exhibition), catalogue

France-Tours, art actuel: première biennale d'art contemporain, Centre de Création Contemporain, Tours, catalogue

Maestros de la fotografía francesa del siglo XX, Fundación San Telmo, Buenos Aires, catalogue

1984

French Spirit Today, Fisher Art Gallery, University of Southern California, Los Angeles (traveling exhibition), catalogue

Le Nouveau Musée de Villeurbanne, Lyons, France, catalogue

Content: A Contemporary Focus, 1974-1984, Hirshhorn Museum and Sculpture Garden, Smithsonian Institution, Washington, D.C., catalogue

Construire les paysages de la photographie: 21 auteurs et plasticiens contemporains, Metz pour la Photographie, France (traveling exhibition), catalogue

Des enfants, Galerie Agathe Gaillard, Paris

Images imaginées, Musée Rimbaud, Charleville, France (traveling exhibition), catalogue

The Contemporary Photograph 1980s: Towards a New Development, Fukuoka Art Museum, Japan, catalogue

Symposium über Fotografie, Forum Stadtpark, Graz, Austria, catalogue

1985

Photographie ouverte, Galerie du Musée de la Photographie, Charleroi, Belgium, catalogue

Paris, New York, Tokyo, Tsukuba Museum of Photography, Japan, catalogue

1986

Constructions et fictions, Fondazione Scientifica Querini-Stampalia, Venice (traveling exhibition), catalogue

Signs of the Real, White Columns, New York

Angles of Vision: French Art Today, 1986 Exxon International Exhibition, The Solomon R. Guggenheim Museum, New York, catalogue

The Magic of the Image, Museum of Contemporary Art, Montreal

Fifty Years of Modern Color Photography, 1936-1986. Photokina, Cologne, catalogue

Photography as Performance, Photographers Gallery, London

SANDY SKOGLUND

In *A Breeze at Work* (1987), Sandy Skoglund moves from the homefront settings of her earlier pieces to the outside world. This work was inspired in part by Edward Hopper's *Office at Night,* though the artist was unaware that the painting is in the Walker collection. The eerie mood of *A Breeze* is characteristic not only of the Hopper painting, but also of Skoglund's previous environments, such as the well-known *Revenge of the Goldfish* (1981) and *Radioactive Cats* (1980). The falling leaves, symbolizing the passage of time, cast a deathlike pall over the piece. Like the proliferating objects in other Skoglund tableaux—from ferns to cats to hangers—the multitude of leaves implies a situation out of control.

In fact, Skoglund controls every detail in her photographs. Going one step beyond the tradition of studio photography, she not only directs the actors' placement and gestures, she also designs and fabricates many of the objects included in the tableaux. Her early morning excursions to Manhattan's Fulton Fish Market before sculpting the goldfish are well-documented. Similarly, she devoted a great deal of time to crafting the wide variety of leaves for *A Breeze*, involving herself for the first time in the technique of bronze casting.

The irony, of course, is that Skoglund labors so hard to make everything in her pieces look natural. In this regard, her work has much in common with commercial advertising photography, including a certain deliberate slickness. Yet, under close scrutiny, Skoglund's environments always lack the degree of perfection that commercial photography requires. The models are sometimes a bit blurry in the photographs, a circumstance that would never be permissible by commercial standards. Moreover, by exhibiting the environments themselves along with the photographs made from them, she discloses her working methods, thus destroying all the illusions so critical to advertising. But the tension Skoglund creates between the naturalistic appearance of the elements and their synthetic situations is one which runs throughout her work. The naturalism in a Skoglund tableau is so reassuring to the viewer that it is easily accepted despite the indications of unreality, be it the color of the cats (green) or the unlikelihood of the activity depicted (fish flying).

The lack of rationality, the improbable or unnatural aspects, lend a surrealistic tone to Skoglund's work. They suggest a dreamlike or sometimes nightmarish state of mind, as in the Magrittean conflation of the indoor office and the outdoor leaves tumbling in the wind in *A Breeze*, or the figures in *Goldfish*, one sleeping, the other sitting on the bed, as if they are having bad dreams.

But this is Surrealism in the service of strong narrative ends, even in the unpeopled tableaux. Skoglund's settings always reek of the ordinary, in this case the general issue office furniture, complete with overflowing wastebaskets. She first introduced fragments of offices in *True Fiction* (1987), a series of paintings using photographic images that was completed just before *A Breeze*. The monochrome version of the office in *A Breeze* reveals a deadening dailiness, which is dramatized by the surrealistic confusion of indoors-outdoors that transforms the mundane into the mysterious. Skoglund herself does not have a story in mind when she begins a piece, but it is fully developed by the time she is ready to photograph. We are never supplied with enough details to reconstruct the story, but the actors are, so that they can behave in a naturalistic way. Even without the narrative details, the specificity with which the environments are rendered implies a compelling human drama. And in all of Skoglund's photographs and tableaux, these dramas inevitably touch upon the theme of fear, rational or otherwise, that lurks within us. There is the fear of a personal nature, as in *A Breeze*, which is, in part, about death. But there is also strong social dimension here and in

works such as *Radioactive Cats* (1980) or *Maybe Babies* (1983). Skoglund puts Surrealism in the service of social and political commentary, as she expresses concerns about the workplace, overpopulation, aging and nuclear war, if not exactly by analogy, then by allusion or hyperbole.

Skoglund fully evolves her ideas within the framework of sculpture and photography. And her training as a painter is apparent in the striking artificial color that has become her trademark. After working in a conceptual mode for a number of years, making laborious drawings whose primary subject was the process by which they were created, in 1976 Skoglund moved to documentary filmmaking and then, after a one-year spell, began to draw again, this time depicting objects from life. It was a period of exploration and experimentation. Within a matter of months, she abandoned drawing for direct photographs of the still-life arrangements she had composed. The similarity of this working process to that of commercial photography, which was, in Skoglund's words, "not an alien activity" but part of our consumer culture, eased her anxieties about engaging in what during the 1970s was considered in certain circles an outmoded artistic enterprise. At the same time, and paradoxically, what attracted her to photography were its traditional—or outmoded— aesthetic properties, that is, the ways in which the photographs could reveal texture and color.

With the development of tableaux more elaborate than objects on a tabletop came the possibility of exhibiting the environments themselves along with the photographs. Beyond the appeal of their commercial "innocence," in the sense that they are unsalable, the three-dimensional versions have an encompassing immediacy. Perhaps most important, they open up the viewing and emotional experience since one is no longer confined to looking through the window dictated by the perimeters of the photograph.

Actors aside, Skoglund's photographs do not correspond precisely to the actual installations, leaf for leaf. It was never her intention to perform some sort of conceptual exercise in which the elements in both were perfectly twinned. When we see the two lined up side by side, "reality" and photograph, we understand and appreciate the differences between working in two and three dimensions. There has been a tradition of "fabricated" photographs for some time, pictures of situations created specifically to be photographed. But Skoglund was one of the first artists to present both sides of the picture. Her images have become American icons in two media, works which, when seen in concert, encourage us to reflect on the meaning of photographic truth and, when viewed independently, retain their integrity and power as commentaries on our culture.

MG

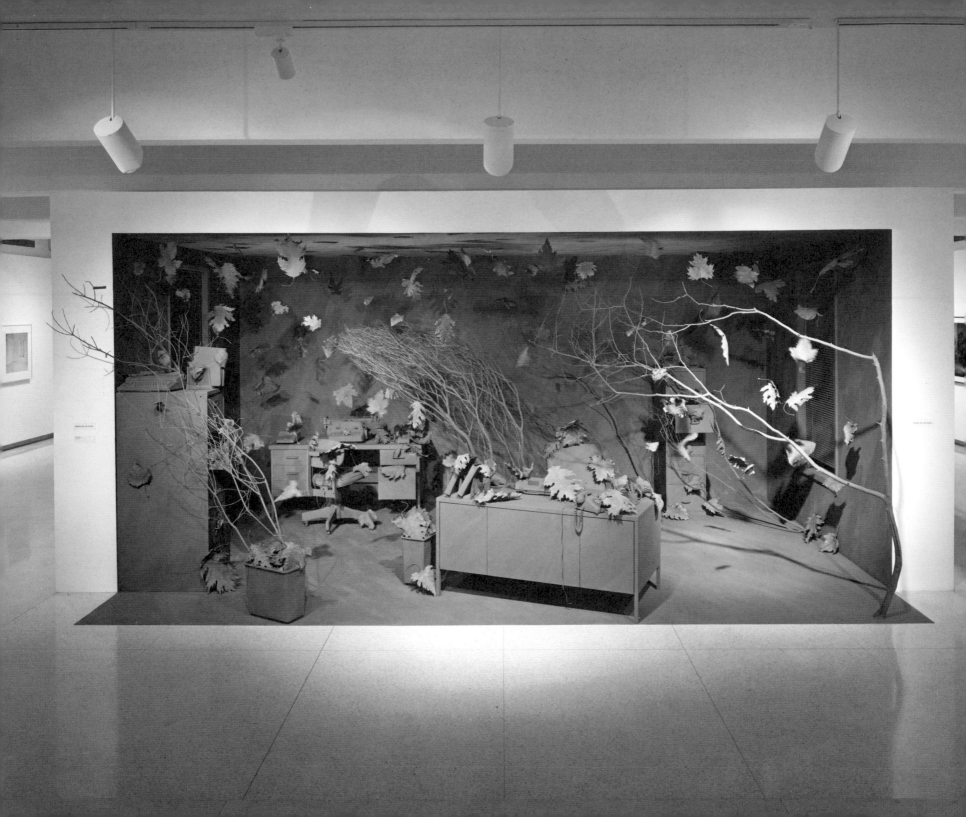

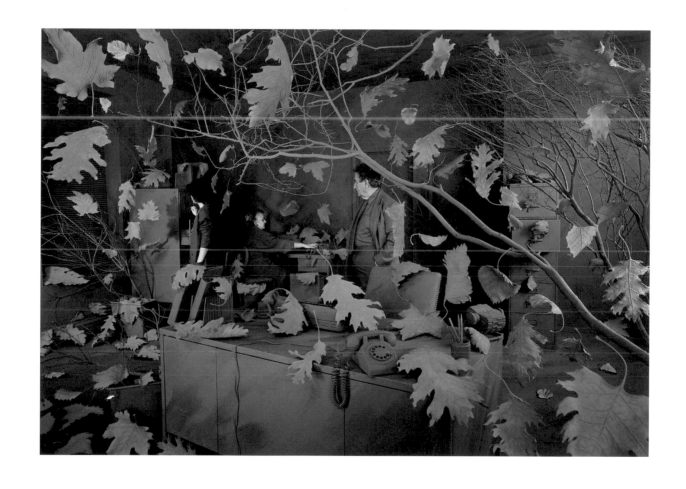

Installation view of
A Breeze at Work 1987
mixed media

A Breeze at Work 1987
Cibachrome

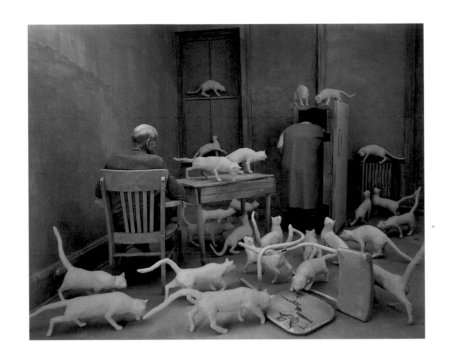

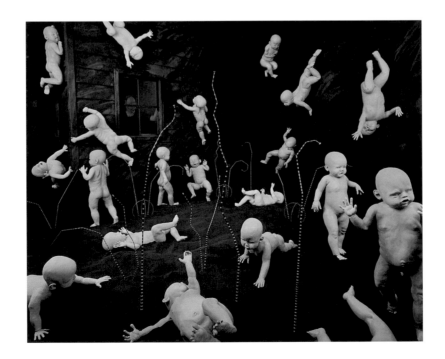

Radioactive Cats 1980
Cibachrome

Maybe Babies 1983
Dye transfer print

SANDY SKOGLUND

1946
Born in Boston, Massachusetts
1968
B.A., Smith College, Northampton,
Massachusetts
1972
M.F.A., University of Iowa, Iowa City

Lives in New York City

Solo Exhibitions
1973
Joseloff Gallery, Hartford Art School,
Connecticut
1974
University of Connecticut, Torrington
1976
Rutgers University, Newark, New Jersey
1980
Radioactive Cats, Real Art Ways Gallery,
Hartford (traveling exhibition)
1981
Revenge of the Goldfish, Castelli Uptown,
New York (traveling exhibition)
1983
Maybe Babies, Leo Castelli Gallery,
New York (traveling exhibition)
1984
Galerie Watari, Tokyo
1987
True Fiction, Castelli Uptown, New York
Neo Auto, Sharpe Gallery, New York

Selected Group Exhibitions
1977
Invitational, 55 Mercer Gallery, New York
1979
Pictures: Photographs, Castelli Uptown,
New York
1980
Interiors, Barbara Gladstone Gallery,
New York
Likely Stories, Castelli Uptown, New York
Contemporary Photographs, Fogg Art
Museum, Harvard University, Cambridge
(traveling exhibition)
1981
*The New Color: A Decade of Color
Photography*, Everson Museum of Art,
Syracuse (traveling exhibition), catalogue
New American Color Photography, Institute
of Contemporary Arts, London
Staged Shots, Delahunty Gallery, Dallas
1981 Biennial Exhibition, Whitney Museum
of American Art, New York, catalogue
Carey/Dwyer/Simmons/Skoglund, Texas
Gallery, Houston

1982
Staged Photo Events, Rotterdamse
Kunststichting, catalogue
Beyond Photography: The Fabricated Image,
Delahunty Gallery, New York
The Atomic Salon, Ronald Feldman Fine Arts,
New York
*Color as Form: A History of Color
Photography*, International Museum of
Photography, George Eastman House,
Rochester, New York (traveling exhibition),
catalogue
1983
Sculpture Now: Recent Figurative Works,
Institute of Contemporary Art of the Virginia
Museum, Richmond
Drawings/Photographs, Leo Castelli Gallery,
New York
Photography in America, 1910-Present,
Tampa Museum, Florida, catalogue
Three-Dimensional Photographs, Castelli
Uptown, New York (traveling exhibition)
*Phototypes: The Development of
Photography in New York City*, Whitney
Museum of American Art, Downtown
Branch, catalogue
Habitats, The Clocktower, New York
Images Fabriquées, Centre Georges
Pompidou, Paris (traveling exhibition),
catalogue
1984
*Anxious Interiors: An Exhibition of Tableau
Photography and Sculpture*, Laguna Beach
Museum of Art, California (traveling
exhibition), catalogue
*The Contemporary Photograph 1980s:
Towards a New Development*,
Fukuoka Art Museum, Japan, catalogue
*Visions of Childhood: A Contemporary
Iconography*, Whitney Museum of American
Art, Downtown Branch, New York
1985
Real Surreal, Lorence-Monk Gallery,
New York
Two Photographers: Skoglund and Pfahl,
Museum of Art, Science, and Industry,
Bridgeport, Connecticut

1986
Photographic Fictions, Whitney Museum of
American Art, Fairfield County, Stamford,
Connecticut
The Magic of the Image, Museum of
Contemporary Art, Montreal, catalogue
*Fifty Years of Modern Color Photography,
1936-1986*, Photokina, Cologne, catalogue
Théâtre des Réalités, Metz pour la
Photographie, France
1987
*This Is Not A Photograph: Twenty Years of
Large-Scale Photography, 1966-1986*,
John and Mable Ringling Museum of Art,
Sarasota (traveling exhibition), catalogue
*Photography and Art: Interactions Since
1946*, Museum of Art, Fort Lauderdale and
Los Angeles County Museum of Art (traveling
exhibition), catalogue

RON O'DONNELL

Ron O'Donnell's photographs of fabricated sets are tacky, humorous, kitschy, ridiculous and brash. But so, too, are they subtle, sober, precise and refined. O'Donnell's work is an art of surprising contrasts and juxtapositions in technique, style and content. Although he never attended art school, his first love has always been painting. He does not consider himself a painter, and has no training in the field, yet he frequently includes painting in his sets, and his large-scale photographs are of a size he associates more commonly with painting than with photography. O'Donnell spent two years studying photography in college and today works as a highly skilled technical photographer in the Department of Civil Engineering at the University of Edinburgh.

O'Donnell's combination of painting and photography creates a strong, unified statement. The qualities distinct to each medium work as complements and counterpoints. His painting, collaging and assembling give the overall image a loose and effortless look. In contrast, the large-format camera, which yields 8 x 10-inch negatives, enables the artist to achieve incredible quality and precision of detail. Thus, from a distance the photograph can be admired for its broad impression, but close inspection reveals the detailed information necessary for a complete understanding of the piece.

Despite his lack of artistic training, O'Donnell wields the paint brush with remarkable sophistication. He is especially adept at visually balancing soft painterly qualities with linear, hard-edged elements. This is perhaps most obvious in *Studio Interior with Black Vase* (1987), O'Donnell's version of Georges Braque's 1958 painting of the same title, in which distinct cutout shapes are carefully delineated with white borders while the interior portions of these amoebic forms tend to be brushy. In *Still Life Is Alive and Kicking* (1986), the contrasts between the spray-painted edges of the torn wallpaper, the well-defined leaf motif on the wall, and the rectilinear

details on the lower right-hand corner of the door are more subtle. Here both painting techniques are fused into a single backdrop. There is also a striking contrast between the distinct contours of the cartoonlike figures both in *90% Pseudosurrealistic Crap* (1986) and *The Flasher* (1985) and the atmospheric brushwork that integrates the assembled and collaged elements in the backgrounds.

O'Donnell has borrowed from and is influenced by diverse artists and styles. His comic-strip figures originated in the Scottish cartoons he found in *The* [Edinburgh] *Sunday Post* and in Pop Art, particularly the work of Roy Lichtenstein, which itself is inspired by comic strips. O'Donnell has also unabashedly cannibalized Georges Braque still lifes and ancient Egyptian hieroglyphics. He is less overtly, though no less significantly, influenced by the surrealistic visual puns of René Magritte and the rich color and precise detail of Joel Meyerowitz's photographs.

O'Donnell fabricates his sets intuitively yet deliberately. In creating *The Scotsman* (1987), he spent months gathering kitsch—searching junk shops and secondhand stores to select objects for his tableau. The objects in his installations appear as a haphazard collection of detritus but they are as carefully staged as props in a theater set. In *The Antechamber of Ramses V in the Valley of the Kings* (1985), objects strategically placed in the room direct the viewer's vision through the space to reveal a story, item by item: a wrought-iron stove burner, a snapshot of a woman and child, a newspaper with a pointed headline—"Huge Bill Ahead For Housing," a coffee cup resting expectantly on an armchair, a pair of worn black work boots, a vase of plastic tulips, a single slice of bread lying abandoned on the floor, a portrait of a boy—in fact the artist himself—in a tartan frame, and a host of other revelatory objects. These clues suggest the plight of a pensioner who revels in the glories of the past but can't afford a decent flat or a proper meal in his old age.

O'Donnell's sets are consistently reminiscent of childhood fascinations. The abandoned, decaying Dickensian tenement in Edinburgh where he creates his fantastic environments is like a child's playhouse. When he finishes a set in one flat he moves to another to begin a new work. Each room offers fresh possibilities and suggests a new scenario—a dancing still life, an unassailable brick-faced detective in search of evidence, a mysterious Egyptian tomb. The movie theater, that institution in every child's life, was the setting for two of O'Donnell's more mischievous and foreboding images: *The Cameo Robot* (1985) features a primitive life-size robot in a ticket booth juxtaposed with the poster image of a terror-stricken starlet; *Odeon 2* (1985) highlights a dramatically lit female mannequin dressed as a roving refreshment concessionaire whose coveted sweets make her alluring, but whose role as disciplinarian in the dark theater makes her simultaneously frightening.

O'Donnell's photographs exhibit more than boyish exuberance and nostalgia; he is a prankster, a rebel at heart. He worked for ten years as a black-and-white documentary photographer in a style influenced by British photographer Bill Brandt and French photographer Henri Cartier-Bresson. In 1984, having learned all that he could from these exemplars, O'Donnell finally came to the realization that he was free, artistically, to do whatever he wanted. At that time he began testing the sanctity of photographic conventions and the bounds of "good taste" by returning glass encased animal specimens, taken from the zoology department of the university, to their natural habitats. A year later he executed his outrageous work *Chip Dinner* (1985), which depicts an unappetizing frozen TV dinner on a spit above a fabricated campfire. This image represents a significant step for O'Donnell; while it utilizes a woodland setting, it is also the origin of his painted and fabricated environments. In *Studio Interior with Black Vase*, entirely constructed by the artist,

O'Donnell pays homage to Georges Braque while simultaneously poking fun at him by including a chicken carcass and a rubber monster hand in his version of the master's still life.

These visual high jinks, which deride both the viewer and the artistic process itself, work so well because they contrast markedly with the beautiful color and satisfying disposition of the composition. For example, in *Christmas Tree* (1985) one can imagine the photograph of the bare, dessicated tree with the charred gifts beneath it as an elegant abstract collage of torn paper.

As a Scotsman, O'Donnell sees himself removed from British culture. His self-deprecating humor, which he considers particularly Scottish, is key to *The Scotsman* installation, originally intended for a Glasgow exhibition. As the artist pointed out, Scottish football teams as a rule perform poorly in international competition but Scots nevertheless have a passion for the sport. The burst football of *The Scotsman*'s head, the overpowering tartan theme, and the pseudo-stag head above the fireplace all caricature fixtures of Scottish society.

O'Donnell regards his works as more anecdotal than political. Although his *Woodland Animal* series could be construed as a statement about animal rights, his *Flasher* a criticism of sexual abuse, his *Christmas Tree* a wry comment on conspicuous consumption, his *Antechamber of Ramses V* a commentary about poverty, and his *Still Life Is Alive and Kicking* an ironic pun relating to the deaths of the Challenger astronauts, the artist would "hate to be thought of as a campaigning photographer." He doesn't want "to make any one point or statement; it's more ambiguous than that." And O'Donnell's work succeeds precisely because it cannot be pinned down. It is formal and narrative, humorous and political, and it is painting, sculpture and assemblage, as well as photography.

ADW

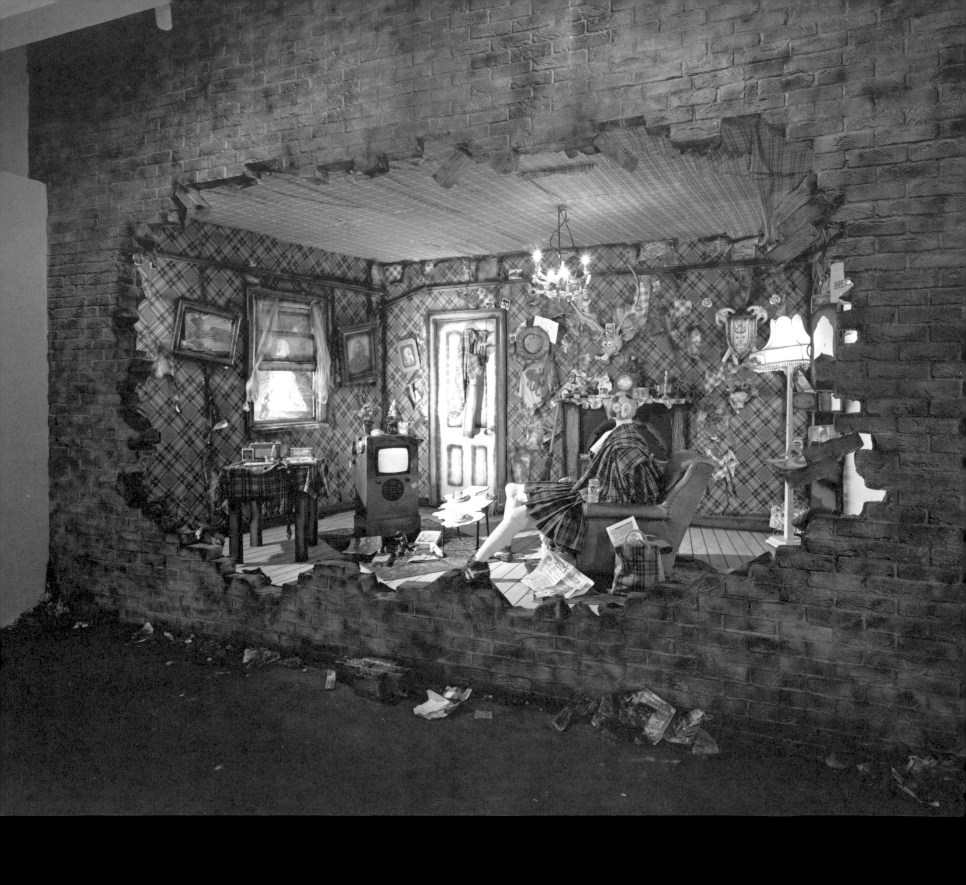

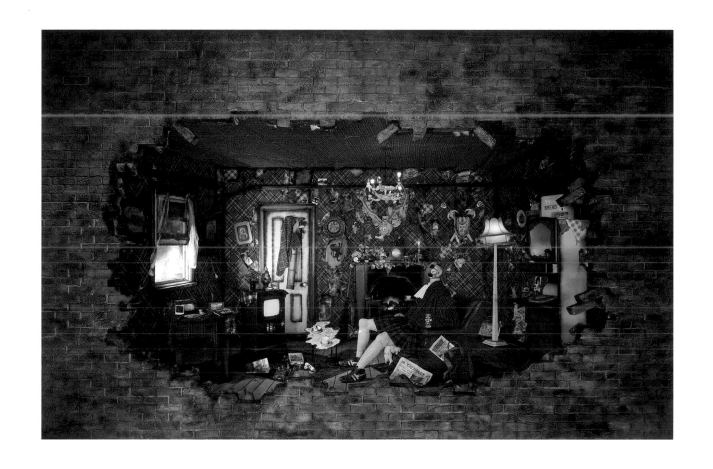

Installation view of
The Scotsman 1987
mixed media

The Scotsman 1987
Type C print

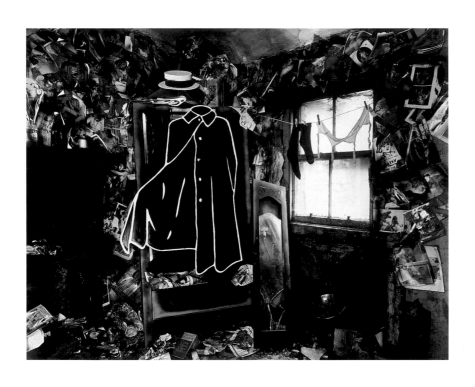

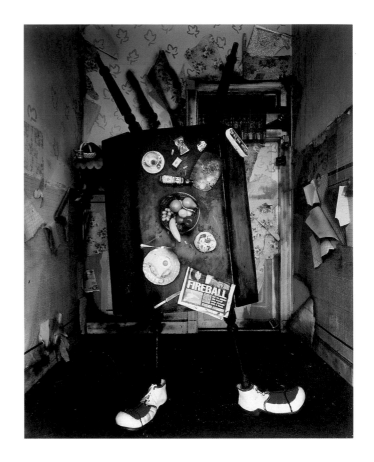

The Flasher 1985
Type C print

Still Life is Alive and Kicking 1986
Type C print

34

RON O'DONNELL

1952
Born in Stirling, Scotland
1970
Trainee photographer, Stirling University
1971-1973
Studied photography,
Napier College, Edinburgh

Lives in Edinburgh

Solo Exhibitions
1973
Commonwealth Arts Institute, Edinburgh
1983
Third Eye Centre, Glasgow
City Arts Centre, Edinburgh
Camden Arts Centre, London
1985
Stills Gallery, Edinburgh

Selected Group Exhibitions
1978
Seven Photographers in Scotland,
Stills Gallery, Edinburgh
1983
Contemporary Camera, Collins Gallery,
Glasgow
1984
City Arts Centre, Aberdeen
Make 'em Laugh, Open Eye Gallery,
Liverpool
1985
Image and Exploration, Photographers
Gallery, London
Insertion and Invention, The British Council
(traveling exhibition)
British Photography for Eastern Europe,
Prague (traveling exhibition)
1986
Constructed Narratives, Photographers
Gallery, London (traveling exhibition),
catalogue
Masters of Photography, Victoria and Albert
Museum, London
1987
Glasgow—A New Look, Collins Gallery,
Glasgow, catalogue
True Stories and Fotofiction, Ffoto Gallery,
Cardiff, Wales
Constructions, Kathleen Ewing Gallery,
Washington, D.C. (traveling exhibition)
The Vigorous Imagination, New Scottish Art,
Scottish National Gallery of Modern Art,
Edinburgh, catalogue

BOYD WEBB

In the final sequence of the film *Scenes and Songs from Boyd Webb* (1984), a woman wearing a black tank suit moves slowly across the screen. She aims a small pink hairdryer at a yellow cube, which turns out to be a large pat of butter, and it slowly melts. The woman seems almost weightless, moving in graceful, swimming motions. The "water" that surrounds her is a cool green, the "sky" above cloudy and gray. At the very end of the film, which was co-directed by Webb, the camera backs away from the scene, breaking the illusion. The machinery of Webb's set is briefly on view, revealing ropes and pulleys, the rough edges of a paper backdrop, and bright lights. Even without knowing the mechanical underpinnings of Webb's tableaux, however, the viewer is constantly made aware that they are pure artifice. The artist draws attention to his devices, emphasizing the fictional aspect of photography.

In the late 1960s, when he was still an art student in New Zealand, Webb made fiberglass sculptures of people cast from life and set in Kienholzian tableaux. Because he had no storage space, he started photographing the sculptures for his records before dismantling them. Webb's photography has become more conceptual over the years, but he still uses the medium to capture life-size, temporary installations composed with people and props. Instead of serving as a tool for documentation, the camera is now a dramatic device, transforming his raw materials into exquisitely arcane images that comment on contemporary life and the human condition.

Webb's images seem to capture a critical moment from an unspecified but bizarre event, an event many viewers immediately try to construe. For his early photographs, made during the 1970s, Webb provided captions. Although hardly delineating an imagined plot, these caustic commentaries offered another level of information, albeit as disconcerting as the visual image. At their most subtle, these images portray unorthodox behavior; more commonly, they suggest humanity at its most perversely inane. In recent years, Webb has enlarged his photographs and reduced his captions to cryptic one- or two-word titles that hint at the work's intention. Purposefully obscure, his photographs probe and ask the viewer to do the same.

In many of his recent photographs, Webb freezes an incongruous array of everyday objects between two artificial realms, creating hypnagogic tableaux—half-waking, half-dreaming visual experiences. In *Nemesis* (1983), a naked man crouches in a dark, underground space, calmly blowing into a thin hose. At the other end of the hose, which is "above ground," the balloon he is blowing up is about to burst, destroying the small house that surrounds it. This man alone can save the house but, being "underground," is unaware of the damage he is inflicting. As in a dream, this image combines the real and unreal and a simultaneous sense of action and stasis. Webb created this surrealistic image with the simplest means: a remnant of synthetic carpet, stretched across the scene, becomes the earth; four long, white radishes—elegant non sequiturs—are cut into the "top soil," enhancing the illusion; a friend posed with a hose. The cavernous expanse underground is, on second glance, composed of large sheets of painted tarpaulin which have been crudely seamed together; a kinky snag of carpet hangs over its pristine edge. The sharp focus of Webb's large-format camera draws attention to these details, intentionally disrupting the photograph's seamlessness.

Webb taunts the viewer to suspend disbelief despite awareness of his artifice. In the opening of *Scenes and Songs,* a group of boys strain to peek inside the front window of the artist's studio in East London. The viewer's curiosity is equally aroused by the scene unfolding through the window frame. Inside, Webb brings his tableaux to life, allowing the actors limited movement within his carefully constructed cosmos. Webb even wrote the lyrics that accompany the film's operatic score. As in opera, one has to strain to

understand the words, which remain as elusive as the imagery. Between each of the eight scenes created for the film, Webb himself appears briefly to present new props, usually simple objects, that will be integral to the following scene: flesh-colored tape, several candles, a carton of yogurt. In these interludes, Webb interrupts the scenic flow to reveal an aspect of his working process, reminding us of the resourceful approach he takes to image-making.

In *Judy* (1984), one of several photographs that grew out of the film, an unlikely and faltering female Atlas strains to balance the great weight of the earth on her shoulders. In contrast to the Greek god, Judy appears to be an everyday mortal, dressed in street clothes and looking justifiably worried. The aerial view of the planet reveals such details as two small houses and a figure precariously perched on its edge. This lofty vantage point, which reveals just how delicate the earth's balance really is, provides a symbolic commentary on the fragility of the planet and its uncertain future.

Much like the staged tableaux of nineteenth-century stereopticon imagery or Victorian genre painting, Webb's works encourage us to examine human behavior. But unlike the Victorians, he does not provide easily decoded morality lessons. His human protagonists are unable to enlighten, immersed as they are in private, highly irrational rituals. A woman carries the weight of the world on her shoulders. Unable to see the consequences of his actions, a man is his own nemesis. Webb is intrigued with man's myopia, with his capacity to ignore the bigger picture. At the same time, he questions whether there is in fact a bigger picture. Is there a preordained structure, an underlying meaning to life? And, if not, what motivates man's persistent will to survive? These questions underly Webb's carefully constructed scenes of futility.

Even when the human figure is absent from his images, it is intimated by attributes, from telephones and music stands to cotton candy and steel wool. In the photographs, these idiosyncratic objects become symbolic satellites in orbit against soaring fields of color (usually speckled or striped sheets of paper)—fantastic abstractions of man's presence in the galaxy. In his sculpture for this exhibition, *Ensemble and Cruet* (1987), Webb has fabricated two gigantic molars complete with roots. Each enlarged to almost five feet high, the teeth make reference to parts of the human anatomy and take on a sensual presence. Suspending one molar over the other, Webb places several violins in the gap between their irregular crowns. The image of these elegant musical instruments, the epitome of high culture, being masticated by the disturbingly organic teeth, is characteristic Webb. Simultaneously beautiful, horrible and bizarre, his incongruous juxtapositions present a vision of a profoundly mysterious universe guided by human foibles.

EA

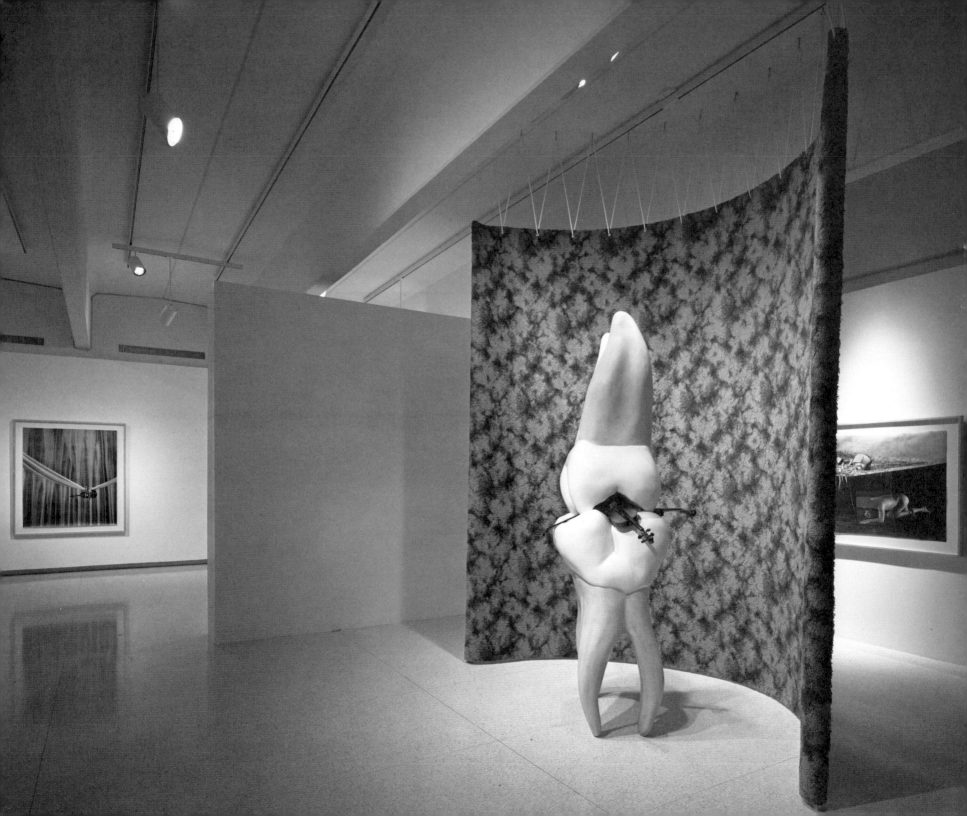

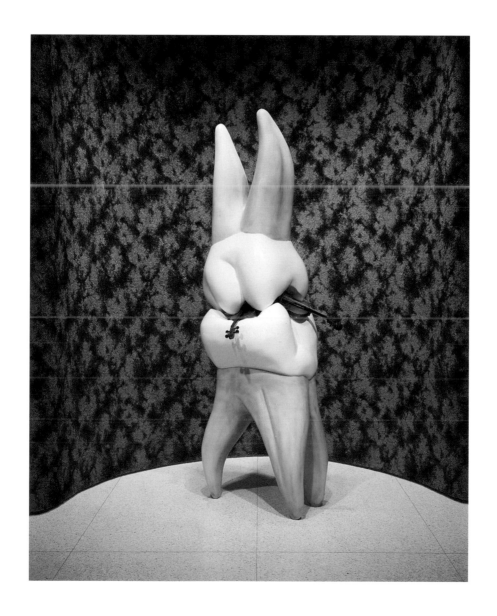

Installation view of
Ensemble and Cruet 1987
mixed media

Ensemble and Cruet 1987
Cibachrome

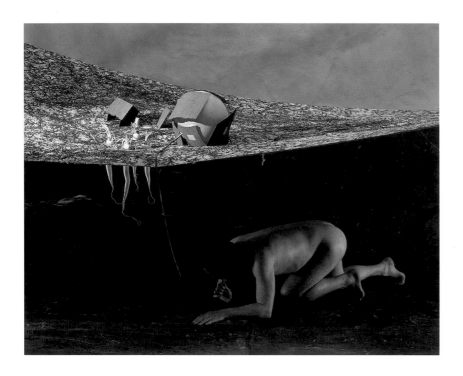

Nemesis 1983
Cibachrome

BOYD WEBB

1947
Born in Christchurch, New Zealand
1975
M.A., Royal College of Art, London

Lives in London

Solo Exhibitions
1976
Robert Self Gallery, London
1977
Graves Art Gallery, Sheffield
Graeme Murray Gallery, Edinburgh
Robert Self Gallery, Newcastle-upon-Tyne
1978
Gray Art Gallery and Museum, Hartlepool
Konrad Fischer Gallery, Düsseldorf
Jean & Karen Bernier, Athens
Arnolfini Gallery, Bristol, England
Whitechapel Art Gallery, London, catalogue
1979
New 57 Gallery, Edinburgh
Sonnabend Gallery, New York
Galerie Sonnabend, Paris
1980
Galerie t'Venster, Rotterdam
1981
*Boyd Webb: Photographic Works,
1976-1981*, Auckland City Art Gallery,
New Zealand, catalogue
Anthony d'Offay Gallery, London
Sonnabend Gallery, New York
John Hansard Gallery, Southampton,
England
1982
Badischer Kunstverein, Karlsruhe, West
Germany (traveling exhibition), catalogue
Jean & Karen Bernier, Athens
1983
Centre Georges Pompidou, Paris
Galerie Chantal Crousel, Paris
Stedelijk Van Abbemuseum, Eindhoven, The
Netherlands (traveling exhibition), catalogue
1984
Boyd Webb: New Work, Anthony d'Offay
Gallery, London
1985
Northern Illinois University Art Gallery,
Chicago (traveling exhibition)
Sonnabend Gallery, New York
Chapter Art Centre, Cardiff, Wales
1986
Jean Bernier, Athens
Adelaide Festival, Adelaide, Australia
(traveling exhibition), catalogue
Sue Crockford Gallery, Auckland,
New Zealand

1987
Whitechapel Art Gallery, London
(traveling exhibition), catalogue

Selected Group Exhibitions
1975
Robert Self Gallery, London
1976
Pan Pacific Biennale, Auckland, New Zealand
1977
Time, Words and the Camera, Künstlerhaus,
Graz, Austria (traveling exhibition)
1979
Europa '79, Stuttgart
With a Certain Smile, INK, Zurich
1980
Boyd Webb/Norbert Wolf, Museum Haus
Lange, Krefeld, West Germany, catalogue
Photographic Contrivances, University
Art Museum, University of California,
Santa Barbara
Artist and Camera, Arts Council of Great
Britain (traveling exhibition)
Photography and the Medium, The British
Council (traveling exhibition)
Sonnabend Gallery, New York
Lisson Gallery, London
1981
Erweiterte Fotografie, Internationale
Biennale, Neue Secession, Vienna, catalogue
Das Porträt in der Fotografie, Rheinisches
Landesmuseum, Bonn
*The New Color: A Decade of Color
Photography*, Everson Museum of Art,
Syracuse (traveling exhibition), catalogue
New Directions, Sidney Janis Gallery, New
York
New Works of Contemporary Art and Music,
Fruitmarket Gallery, Edinburgh
Galerie Chantal Crousel, Paris
P.S. 1, Long Island City, New York
Sonnabend Gallery, New York
Anthony d'Offay Gallery, London
1982
*Color as Form: A History of Color
Photography*, International Museum of
Photography, George Eastman House,
Rochester, New York (traveling exhibition),
catalogue
Fourth Biennale of Sydney, Australia

Documenta 7, Kassel, West Germany,
catalogue
Galerie Chantal Crousel, Paris
Staged Photo Events, Rotterdamse
Kunststiching, catalogue
1983
The Sculpture Show, Hayward Gallery,
London
Images Fabriquées, Centre Georges
Pompidou, Paris (traveling exhibition),
catalogue
1984
*Anxious Interiors: An Exhibition of Tableau
Photography and Sculpture*, Laguna Beach
Museum of Art, California (traveling
exhibition), catalogue
1985
XIII Biennale de Paris, Grande Halle
de la Villette, Paris, catalogue
Alles und noch viel mehr, Kunsthalle, Bern,
Switzerland
The Irresistible Object: Still Life 1600-1985,
Leeds City Art Gallery, Leeds
Atelier Polaroid, Centre Georges Pompidou,
Paris
1986
Forty Years of Modern Art 1945-1985,
Tate Gallery, London
Signs of the Real, White Columns, New York
Sculpture: 9 Artists from England,
Louisiana Museum, Humlebaek, Denmark
The Real Big Picture, The Queens Museum,
Flushing, New York
Prospect 86, Frankfurter Kunstverein und
Schirn Kunsthalle, Frankfurt, catalogue
Collection Souvenir, Le Nouveau Musée,
Lyon, France
Aperto 86, XLII Venice Biennale, catalogue
*Contrariwise: Surrealism and Britain
1930-1986*, Glynn Vivian Art Gallery,
Swansea, Wales (traveling exhibition)
1987
'Blow Up' Zeitgeschichte, Württembergischer
Kunstverein, Stuttgart (traveling exhibition)

Film
1984
Scenes and Songs from Boyd Webb. 16mm
color film, transferred to video, co-directed
by Boyd Webb and Philip Haas. 20 mins.

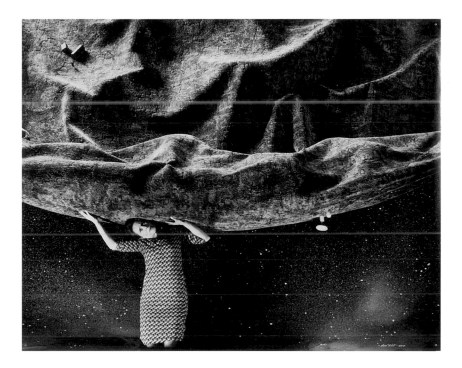

Judy 1984
Cibachrome

Exhibition Checklist

JAMES CASEBERE

Unless otherwise indicated,
dimensions are in inches;
height precedes width precedes depth.

Installation

*Western Sculpture with Two Wagons and
Cannon* 1987
styrofoam, wood, epoxy, fiberglass, paint
144 x 378 x 118

Photographs

Arches 1985
Duratran with lightbox
40 x 50
Collection The Capital Group, Inc.,
Los Angeles

Needles 1985
two silverprints
30 x 40 each
Courtesy Michael Klein, Inc., New York

Pulpit 1985
Duratran with lightbox
50 x 40
Courtesy Michael Klein, Inc., New York

Covered Wagons 1986
Duratran with lightbox
50 x 40
Courtesy Michael Klein, Inc., New York

Golden Apple 1986
Silverprint
30 x 40
Courtesy Michael Klein, Inc., New York

Western Street 1986
Silverprint
30 x 40
Courtesy Michael Klein, Inc., New York

Western Warplay 1986
Duratran with lightbox
30 x 40
Courtesy Michael Klein, Inc., New York

BRUCE CHARLESWORTH

Installation
Private House 1987
mixed media with audio and video elements
134 x 477 x 321

Photographs
Untitled 1983
Cibachrome
23 x 23
Courtesy Thomas Barry Fine Arts,
Minneapolis

Untitled 1984
Cibachrome
23 x 23
Collection Walker Art Center,
Jerome Foundation Purchase Fund for
Emerging Artists, 1985

Untitled 1984
Cibachrome
23 x 23
Collection Dr. Paul Sternberg, Jr., Atlanta

Untitled 1984
Cibachrome
23 x 23
Private Collection

Untitled 1985
Cibachrome
23 x 23
Collection Walker Art Center,
Jerome Foundation Purchase Fund for
Emerging Artists, 1985

Untitled 1985
Cibachrome
23 x 23
Collection First Bank System, Inc.,
Minneapolis

Untitled 1985
Cibachrome
23 x 23
Collection First Bank System, Inc.,
Minneapolis

Untitled 1986
Cibachrome
23 x 23
Collection First Bank System, Inc.,
Minneapolis

Untitled 1986
Cibachrome
23 x 23
Collection First Bank System, Inc.,
Minneapolis

Untitled 1987
Cibachrome
23 x 23
Courtesy Thomas Barry Fine Arts,
Minneapolis

Videotape
Dateline for Danger 1987
Videotape, color, sound, 24 mins.
Writer, director, editor: Bruce Charlesworth
Music: John Franzen
Lighting: Michael Murnane
Camera: Skip Davis
Sound: Ben James
Production manager: Dan Satorius
Editing technician: Alexei Levine
Actors: Erika—Elizabeth Stifter;
Doug—R. Scott Taylor; Rafe—Scott Thun;
Ginny—Buffy Sedlachek;
Major Zorax—George Muschamp;
Vago—Bruce Charlesworth
Courtesy the artist

BERNARD FAUCON

Installation
The Wave of Snow 1987
sugar, glass
55¼ x 157½ x 67

Photographs
The First Room of Love 1984
Fresson print
24¾ x 24¾
Courtesy Castelli Uptown, New York

*Exterior Room of Love
(The Second Room of Love)* 1985
Fresson print
24¾ x 24¾
Courtesy Castelli Uptown, New York

The Fourth Room of Love 1985
Fresson print
24¾ x 24¾
Courtesy Castelli Uptown, New York

The Fifth Room of Love 1985
Fresson print
24¾ x 24¾
Courtesy Castelli Uptown, New York

*The Mirror of Milk
(The Seventh Room of Love)* 1985
Fresson print
24¾ x 24¾
Courtesy Castelli Uptown, New York

*The Coals
(The Ninth Room of Love)* 1985
Fresson print
24¾ x 24¾
Courtesy Castelli Uptown, New York

The Twelfth Room of Love 1985
Fresson print
24¾ x 24¾
Courtesy Castelli Uptown, New York

*The Stained Glass
(The Thirteenth Room of Love)* 1985
Fresson print
24¾ x 24¾
Courtesy Castelli Uptown, New York

*The Snow Storm
(The Fourteenth Room of Love)* 1985
Fresson print
24¾ x 24¾
Courtesy Castelli Uptown, New York

*The Twins
(The Fifteenth Room of Love)* 1986
Fresson print
24¾ x 24¾
Courtesy Castelli Uptown, New York

*The Room of the Pharoah
(The Sixteenth Room of Love)* 1986
Fresson print
24¾ x 24¾
Courtesy Castelli Uptown, New York

The Seventeenth Room of Love 1986
Fresson print
24¾ x 24¾
Courtesy Castelli Uptown, New York

*The Shroud
(The Eighteenth Room of Love)* 1986
Fresson print
24¾ x 24¾
Courtesy Castelli Uptown, New York

The Nineteenth Room of Love 1986
Fresson print
24¾ x 24¾
Courtesy Castelli Uptown, New York

The Last Room of Love 1986
Fresson print
24¾ x 24¾
Courtesy Castelli Uptown, New York

Room in Winter 1987
Fresson print
24¾ x 24¾
Courtesy Castelli Uptown, New York

RON O'DONNELL

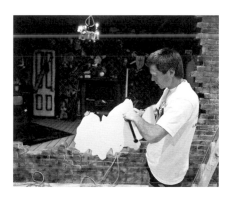

Installation
The Scotsman 1987
mixed media
118 x 220 x 121

Photographs
*The Antechamber of Ramses V
in the Valley of the Kings* 1985
Type C print
37 x 41¼
Courtesy the artist

The Cameo Robot 1985
Type C print
36 x 41¼
Courtesy the artist

The Christmas Tree 1985
Type C print
34½ x 41¼
Courtesy the artist

The Flasher 1985
Type C print
36½ x 41¼
Courtesy the artist

Odeon 2 1985
Type C print
34¾ x 41¼
Courtesy the artist

90% Pseudo Surrealistic Crap 1986
Type C print
37 x 41¼
Courtesy the artist

Still Life Is Alive and Kicking 1986
Type C print
34¾ x 41¼
Courtesy the artist

The Scotsman 1987
Type C print
72 x 96
Courtesy the artist

Studio Interior with Black Vase 1987
Type C print
36½ x 41¼
Courtesy the artist

SANDY SKOGLUND

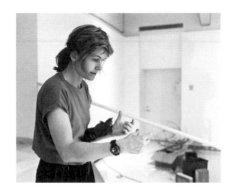

Installation
A Breeze at Work 1987
mixed media
107 x 229 x 145

Photographs
Hangers 1980
Cibachrome
30 x 40
Courtesy Castelli Uptown, New York

Ladies with Ferns 1980
Cibachrome
30 x 40
Courtesy Castelli Uptown, New York

Radioactive Cats 1980
Cibachrome
30 x 40
Courtesy Castelli Uptown, New York

Revenge of the Goldfish 1981
Cibachrome
30 x 40
Courtesy Castelli Uptown, New York

Maybe Babies 1983
Dye transfer print
30 x 40
Courtesy Castelli Uptown, New York

Germs Are Everywhere 1984
Cibachrome
30 x 40
Courtesy Castelli Uptown, New York

A Breeze at Work 1987
Cibachrome
40 x 60
Courtesy Castelli Uptown, New York

BOYD WEBB

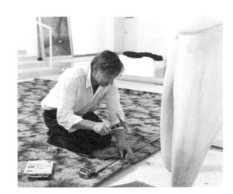

Installation

Ensemble and Cruet 1987
mixed media
137 x 116 x 65

Photographs

Nemesis 1983
Cibachrome
37½ x 47¼
Collection A. Robert Towbin, New York

Judy 1984
Cibachrome
48 x 60
Collection First Bank System, Inc.,
Minneapolis

New Rules 1985
Cibachrome
60 x 48
Collection Arts Council of Great Britain,
London

Yoke 1987
Cibachrome
60 x 48
Courtesy Anthony d'Offay Gallery, London

Truss 1987
Cibachrome
48 x 60
Courtesy Anthony d'Offay Gallery, London

Ensemble and Cruet 1987
Cibachrome
60 x 48
Courtesy Anthony d'Offay Gallery, London

Film

Scenes and Songs from Boyd Webb
1984
16mm color film, transferred to video,
20 mins.
Producer: Philip Haas
Directors: Boyd Webb and Philip Haas
Camera: Wolfgang Suschitzky
Sound: Martin Müller
Editor: Julian Sabath
Music: Marc Wilkinson
Production Company: Methodact Limited
Courtesy Arts Council of Great Britain,
London

Walker Art Center Staff for the Exhibition

Director
Martin Friedman

Curators
Elizabeth Armstrong
Marge Goldwater
Adam D. Weinberg

Curatorial Intern
Nora M. Heimann

Secretarial Assistance
Brian Hassett
Michelle Piranio
Sheri Stearns

Publication Design
Jeffrey Cohen
Lorraine Ferguson

Typesetting
Lucinda Gardner

Registration and Shipping
Sharon Howell

Public Information
Karen Statler

Budget Supervision
Mary Polta

Slide Tape Production
Charles Helm
Karen Dykstra
Nora M. Heimann

Photography
Glenn Halvorson
Peter Latner

Exhibition Installation
Steve Ecklund
Nick Bauman
Greg Benson
Nancy Chute
Phil Docken
Ken Geisen
Mary Gervais
Tim Glaseman
Tom Grant
Laura Hampton
Earl Kendall
Richard Lee
Tom Mason
Sue Matlin
Mark Nielsen
Rob Odegard
Sandra O'Shaughnessy
Owen Osten
Therese Privitera
Kathleen Schuetz
Greg Van Bellinger
Jon Voils
Steve Williams